ART
MATTERS

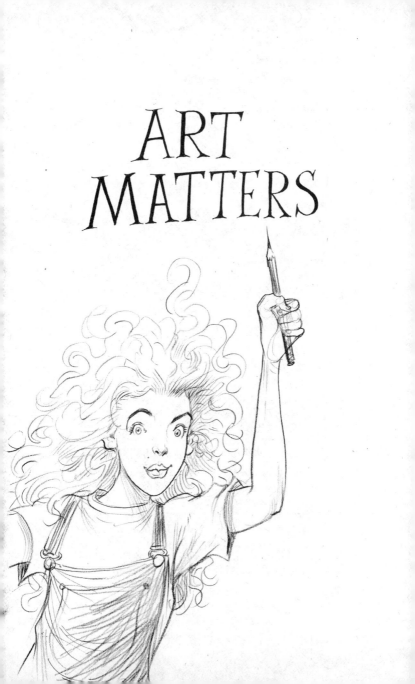

Also by Neil Gaiman

NOVELS

The Ocean at the End of the Lane
The Graveyard Book
Anansi Boys
Coraline
American Gods
Stardust
Neverwhere

NONFICTION

Make Good Art
The View from the Cheap Seats
Art Matters

COLLECTIONS

Trigger Warning
Fragile Things
Smoke and Mirrors

ILLUSTRATED STORIES

The Truth Is a Cave in the Black Mountains
(illustrated by Eddie Campbell)
The Sleeper and the Spindle
(illustrated by Chris Riddell)

FOR YOUNGER READERS

Fortunately, the Milk (illustrated by Skottie Young)
Hansel and Gretel (illustrated by Lorenzo Mattotti)
Instructions (illustrated by Charles Vess)
Odd and the Frost Giants (illustrated by Brett Helquist)
Crazy Hair (illustrated by David McKean)
Blueberry Girl (illustrated by Charles Vess)
The Dangerous Alphabet (illustrated by Gris Grimly)
M Is for Magic (illustrated by Teddy Kristiansen)

Neil Gaiman
ART MATTERS

ILLUSTRATED BY
Chris Riddell

wm
WILLIAM MORROW
An Imprint of HarperCollins*Publishers*

I LOVE THE WAY WORDS AND
PICTURES WORK TOGETHER ON
A PAGE. I HAVE ALSO NOTICED
HOW WHEN WISE WORDS HAVE
VISUALS ADDED TO THEM, THEY
SEEM TO TRAVEL FURTHER
ONLINE, LIKE PAPER AEROPLANES
CATCHING AN UPDRAUGHT. NEIL'S
WORDS ARE SOME OF THE WISEST
I'VE FOUND, AND THE RESPONSE
WHEN I ILLUSTRATE THEM AND
POST ONLINE HAS BEEN WONDERFUL.
IT IS AN EVEN GREATER PLEASURE
TO SEE THEM COLLECTED IN THE
PAGES OF A SMALL, ELEGANTLY BOUND
BOOK.

CHRIS RIDDELL

CONTENTS

'THE WORLD ALWAYS SEEMS
BRIGHTER WHEN YOU'VE JUST
MADE SOMETHING THAT
WASN'T THERE BEFORE'

NEIL GAIMAN

CREDO

I BELIEVE THAT IT IS DIFFICULT TO KILL AN IDEA BECAUSE IDEAS ARE INVISIBLE AND CONTAGIOUS, AND THEY MOVE FAST.

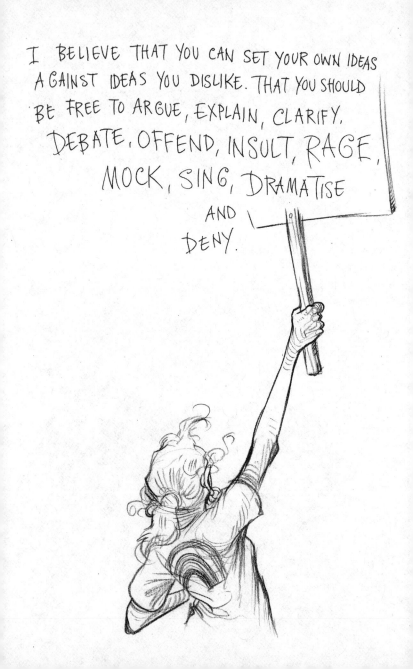

I DO NOT BELIEVE THAT BURNING,
MURDERING, EXPLODING PEOPLE,
SMASHING THEIR HEADS WITH ROCKS
(TO LET THE BAD IDEAS OUT),
DROWNING THEM OR EVEN DEFEATING THEM
WILL WORK TO CONTAIN IDEAS YOU
DO NOT LIKE.

IDEAS SPRING UP WHERE YOU DO NOT EXPECT THEM, LIKE WEEDS, AND ARE AS DIFFICULT TO CONTROL.

I BELIEVE THAT REPRESSING IDEAS SPREADS IDEAS.

I BELIEVE THAT PEOPLE AND BOOKS AND NEWSPAPERS ARE CONTAINERS FOR IDEAS, BUT THAT BURNING PEOPLE WHO HOLD THE IDEAS WILL BE AS UNSUCCESSFUL AS FIREBOMBING THE NEWSPAPER ARCHIVES. IT IS ALREADY TOO LATE.

IT IS ALWAYS TOO LATE.

THE IDEAS ARE ALREADY OUT, HIDING BEHIND PEOPLE'S EYES, WAITING IN THEIR THOUGHTS.

THEY CAN BE WHISPERED.

THEY CAN BE WRITTEN ON WALLS IN THE DEAD OF NIGHT.

THEY CAN BE DRAWN.

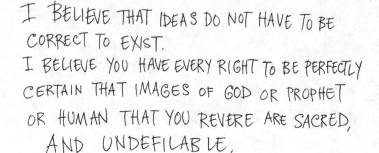

I BELIEVE THAT IDEAS DO NOT HAVE TO BE CORRECT TO EXIST.
I BELIEVE YOU HAVE EVERY RIGHT TO BE PERFECTLY CERTAIN THAT IMAGES OF GOD OR PROPHET OR HUMAN THAT YOU REVERE ARE SACRED, AND UNDEFILABLE,

JUST AS I HAVE THE RIGHT TO BE CERTAIN OF THE SACREDNESS OF SPEECH, AND OF THE SANCTITY OF THE RIGHT

TO MOCK, COMMENT, TO ARGUE AND TO UTTER.

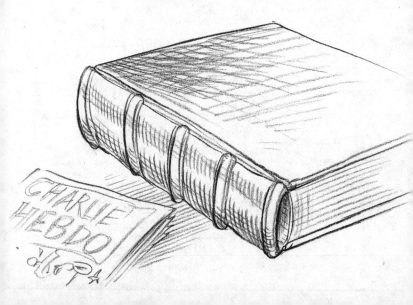

I BELIEVE I HAVE THE RIGHT TO THINK
AND SAY THE WRONG THINGS.
I BELIEVE YOUR REMEDY FOR THAT
SHOULD BE TO ARGUE WITH ME OR TO
IGNORE ME.
AND THAT I SHOULD HAVE THE SAME
REMEDY FOR THE WRONG THINGS THAT
I BELIEVE YOU THINK.

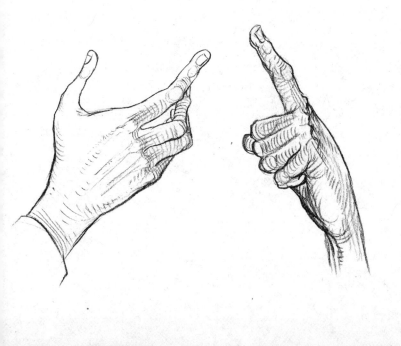

I BELIEVE THAT YOU HAVE THE ABSOLUTE
RIGHT TO THINK THINGS THAT I FIND
OFFENSIVE, STUPID, PREPOSTEROUS OR DANGEROUS,
AND THAT YOU HAVE THE RIGHT TO SPEAK,
WRITE OR DISTRIBUTE THESE THINGS, AND THAT
I DO NOT HAVE THE RIGHT TO
KILL YOU, MAIM YOU, HURT YOU OR
TAKE AWAY YOUR LIBERTY OR PROPERTY BECAUSE
I FIND YOUR IDEAS THREATENING OR
INSULTING OR DOWNRIGHT DISGUSTING.

YOU PROBABLY THINK SOME OF MY IDEAS
ARE PRETTY VILE TOO.

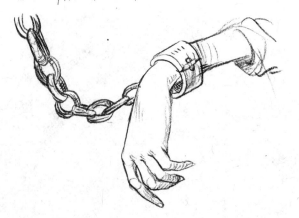

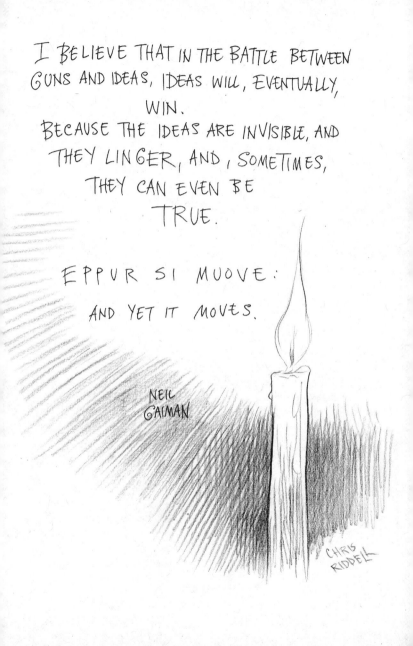

WHY OUR FUTURE DEPENDS ON LIBRARIES, READING AND DAYDREAMING

I SUGGEST THAT
READING FICTION, THAT READING FOR PLEASURE,
IS ONE OF THE MOST IMPORTANT
THINGS ONE CAN DO.

I'M MAKING A PLEA FOR PEOPLE TO
UNDERSTAND WHAT LIBRARIES AND LIBRARIANS
ARE, AND TO PRESERVE BOTH OF THESE
THINGS.

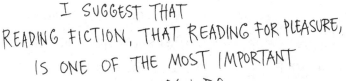

IT IS OBVIOUSLY IN MY INTEREST FOR PEOPLE TO READ, FOR THEM TO READ FICTION, FOR LIBRARIES AND LIBRARIANS TO EXIST AND HELP FOSTER A LOVE OF READING AND PLACES IN WHICH READING CAN OCCUR.

SO I'M BIASED AS A WRITER.

BUT I AM MUCH, MUCH MORE BIASED AS A READER.

EVERYTHING CHANGES WHEN WE READ.

PEOPLE WHO CANNOT UNDERSTAND EACH OTHER
CANNOT EXCHANGE IDEAS, CANNOT COMMUNICATE.
THE SIMPLEST WAY TO MAKE SURE THAT WE
RAISE LITERATE CHILDREN IS TO TEACH THEM
TO READ,
AND TO SHOW THEM THAT READING IS A
PLEASURABLE ACTIVITY.

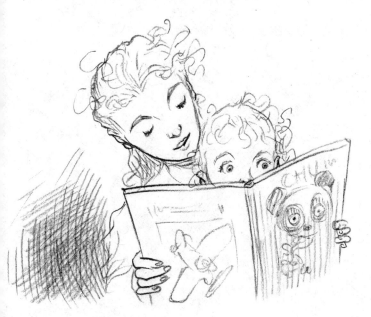

I DON'T THINK THERE IS SUCH A THING AS A
BAD BOOK FOR CHILDREN.

IT'S TOSH. IT'S SNOBBERY AND IT'S FOOLISHNESS.

WE NEED OUR CHILDREN TO GET ONTO THE
READING LADDER: ANYTHING THAT THEY ENJOY
READING WILL MOVE THEM UP, RUNG BY RUNG,
INTO LITERACY.

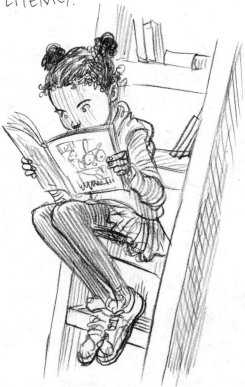

YOU'RE FINDING OUT SOMETHING AS YOU READ THAT WILL BE VITALLY IMPORTANT FOR MAKING YOUR WAY IN THE WORLD. AND IT'S THIS:

THE WORLD DOESN'T HAVE TO BE LIKE THIS.

THINGS CAN BE DIFFERENT.

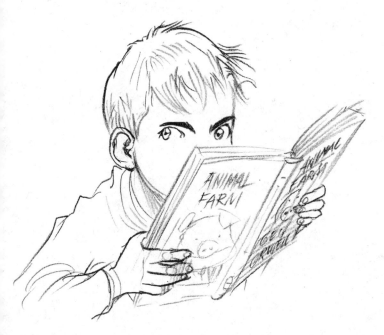

FICTION BUILDS EMPATHY.

FICTION IS SOMETHING YOU BUILD UP FROM TWENTY-SIX LETTERS AND A HANDFUL OF PUNCTUATION MARKS, AND YOU, AND YOU ALONE, USING YOUR IMAGINATION, CREATE A WORLD, AND PEOPLE IT AND LOOK OUT THROUGH OTHER EYES.

YOU'RE BEING SOMEONE ELSE, AND WHEN YOU RETURN TO YOUR OWN WORLD, YOU'RE GOING TO BE SLIGHTLY CHANGED.

I WAS LUCKY. I HAD AN EXCELLENT LOCAL
LIBRARY GROWING UP, AND MET THE KIND OF
LIBRARIANS WHO DID NOT MIND A SMALL,
UNACCOMPANIED BOY HEADING BACK INTO THE
CHILDREN'S LIBRARY EVERY MORNING AND
WORKING HIS WAY THROUGH THE CARD CATALOGUE,
LOOKING FOR BOOKS WITH
GHOSTS OR MAGIC OR ROCKETS
IN THEM,
LOOKING FOR VAMPIRES OR DETECTIVES OR
WITCHES OR WONDERS.

THEY WERE GOOD LIBRARIANS. THEY LIKED BOOKS
AND THEY LIKED THE BOOKS BEING READ.
THEY HAD NO SNOBBERY ABOUT ANYTHING I READ.
THEY JUST SEEMED TO LIKE THAT THERE WAS
THIS WIDE-EYED LITTLE BOY WHO LOVED
TO READ, AND THEY WOULD TALK TO ME
ABOUT THE BOOKS I WAS READING.
THEY WOULD FIND ME OTHER BOOKS.
THEY WOULD HELP.
THEY TREATED ME WITH RESPECT. I WAS NOT
USED TO BEING TREATED WITH RESPECT AS AN
EIGHT-YEAR-OLD.

LIBRARIES ARE ABOUT FREEDOM.
FREEDOM TO READ, FREEDOM OF IDEAS,
FREEDOM OF COMMUNICATION.
THEY ARE ABOUT EDUCATION,
ABOUT ENTERTAINMENT, ABOUT
MAKING SAFE SPACES AND
ABOUT ACCESS TO INFORMATION.

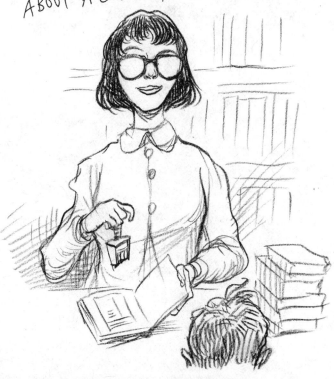

I DO NOT BELIEVE THAT ALL BOOKS WILL OR
SHOULD MIGRATE ONTO SCREENS:
AS DOUGLAS ADAMS ONCE POINTED OUT TO ME,
OVER TWENTY YEARS BEFORE DIGITAL BOOKS
SHOWED UP, A PHYSICAL BOOK IS LIKE
A SHARK.

SHARKS ARE OLD: THERE WERE SHARKS
IN THE OCEAN BEFORE THE DINOSAURS. AND
THE REASON THERE ARE STILL SHARKS AROUND IS
THAT SHARKS ARE BETTER AT BEING SHARKS
THAN ANYTHING ELSE IS.

PHYSICAL BOOKS ARE TOUGH, HARD TO DESTROY, BATH RESISTANT, SOLAR OPERATED, FEEL GOOD IN YOUR HAND:
THEY ARE GOOD AT BEING BOOKS, AND THERE WILL ALWAYS BE A PLACE FOR THEM.

A LIBRARY IS A PLACE OF SAFETY, A HAVEN FROM THE WORLD.

IT'S A PLACE WITH LIBRARIANS IN IT.

WE NEED TO TEACH OUR CHILDREN TO READ
AND TO ENJOY READING.
WE NEED LIBRARIES. WE NEED BOOKS.
WE NEED LITERATE CITIZENS.

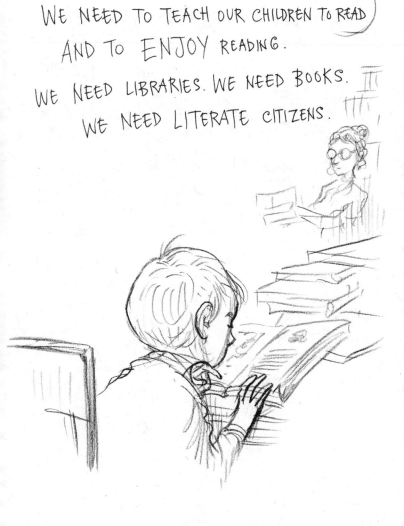

BOOKS ARE THE WAY THAT THE DEAD
 COMMUNICATE WITH US.
THE WAY THAT WE LEARN LESSONS FROM THOSE
WHO ARE NO LONGER WITH US, THE WAY
THAT HUMANITY HAS BUILT ON ITSELF, PROGRESSED,
 MADE KNOWLEDGE INCREMENTAL
 RATHER THAN SOMETHING THAT HAS TO BE
 RELEARNED, OVER AND OVER.

WE HAVE AN OBLIGATION TO READ
 FOR PLEASURE. IF OTHERS SEE US
READING, WE SHOW THAT READING IS
 A GOOD THING.
WE HAVE AN OBLIGATION TO SUPPORT
 LIBRARIES,
TO PROTEST THE CLOSURE OF
 LIBRARIES.
IF YOU DO NOT VALUE LIBRARIES YOU ARE
SILENCING THE VOICES OF THE PAST AND
YOU ARE DAMAGING THE FUTURE.

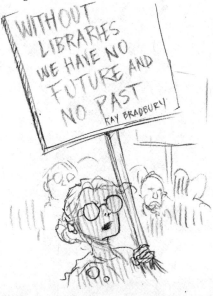

FICTION IS THE LIE THAT TELLS
 THE TRUTH.
WE ALL HAVE AN OBLIGATION TO DAYDREAM.
WE HAVE AN OBLIGATION TO
 IMAGINE.

IT IS EASY TO PRETEND THAT NOBODY CAN
CHANGE ANYTHING, THAT SOCIETY IS HUGE
AND THE INDIVIDUAL IS LESS THAN NOTHING.
 BUT THE TRUTH IS

INDIVIDUALS MAKE THE FUTURE,
AND THEY DO IT BY IMAGINING
 THAT
 THINGS CAN BE DIFFERENT.

ALBERT EINSTEIN WAS ONCE ASKED HOW
WE COULD MAKE OUR CHILDREN INTELLIGENT.

'IF YOU WANT YOUR CHILDREN TO BE
 INTELLIGENT,' HE SAID, ' READ THEM
FAIRYTALES. IF YOU WANT THEM TO BE
MORE INTELLIGENT, READ THEM
 MORE FAIRY TALES.'

I HOPE WE CAN GIVE OUR CHILDREN A WORLD IN
WHICH THEY WILL READ, AND BE READ TO,

AND IMAGINE,

AND

UNDERSTAND.

NEIL GAIMAN

CHRIS RIDDELL

MAKING A CHAIR

33

TODAY I INTENDED TO BEGIN TO WRITE.
STORIES ARE WAITING LIKE DISTANT THUNDERSTORMS
GRUMBLING AND FLICKERING ON THE
 GREY HORIZON

 AND THERE ARE EMAILS AND INTRODUCTIONS
AND A BOOK, A WHOLE DAMN BOOK
ABOUT A COUNTRY AND A JOURNEY AND
 BELIEF

 I'M HERE TO WRITE.

THE CARABAS

I MADE A CHAIR.
I OPENED A CARDBOARD BOX WITH A BLADE
 (I ASSEMBLED THE BLADE)
REMOVED THE PARTS, CARRIED THEM, CAREFULLY,
 UP THE STAIRS.

'FUNCTIONAL SEATING FOR TODAY'S WORKPLACE'
I PRESSED FIVE CASTERS INTO THE BASE,
LEARNED THAT THEY PRESS IN WITH A MOST
SATISFYING POP.

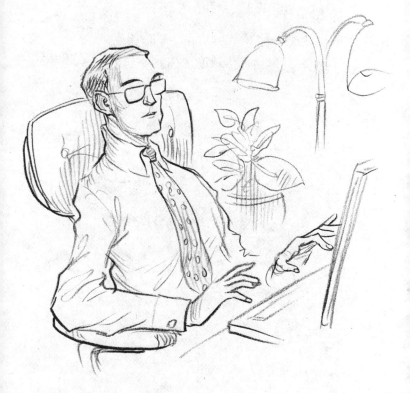

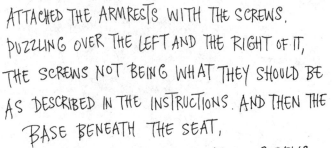

ATTACHED THE ARMRESTS WITH THE SCREWS,
PUZZLING OVER THE LEFT AND THE RIGHT OF IT,
THE SCREWS NOT BEING WHAT THEY SHOULD BE
AS DESCRIBED IN THE INSTRUCTIONS. AND THEN THE
BASE BENEATH THE SEAT,
WHICH ATTACHED WITH SIX 40 mm SCREWS
(THAT WERE PUZZLINGLY SIX 45 mm SCREWS).

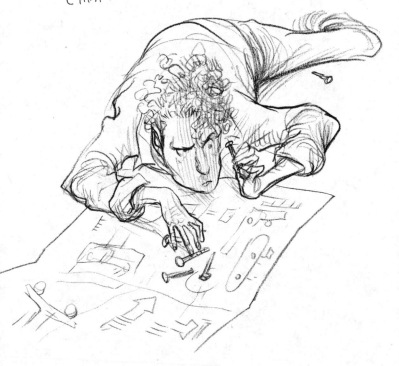

THEN THE HEADPIECE TO THE CHAIRBACK,
THE CHAIRBACK TO THE SEAT, WHICH IS WHERE
 THE PROBLEMS START AS
 THE MIDDLE SCREW ON EITHER SIDE DECLINES
 TO PENETRATE AND THREAD.

THIS ALL TAKES TIME. ORSON WELLES IS HARRY LIME
ON THE OLD RADIO AS I ASSEMBLE MY CHAIR.

 ORSON MEETS A DAME
AND A CROOKED FORTUNE-TELLER, AND A FAT MAN,
AND A NEW YORK GANG BOSS IN EXILE,
AND HAS SLEPT WITH THE DAME, SOLVED THE
 MYSTERY,
 READ THE SCRIPT
 AND POCKETED THE MONEY
 BEFORE I HAVE ASSEMBLED MY CHAIR.

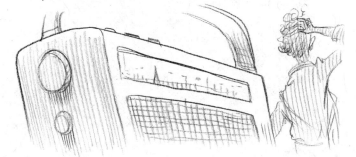

MAKING A BOOK IS A LITTLE LIKE MAKING A CHAIR.
PERHAPS IT OUGHT TO COME WITH WARNINGS,
 LIKE THE CHAIR INSTRUCTIONS.
A FOLDED PIECE OF PAPER SLIPPED INTO EACH COPY,
 WARNING US:
 'ONLY FOR ONE PERSON AT A TIME'

'DO NOT USE AS A STOOL OR A STEPLADDER.'

'FAILURE TO FOLLOW THESE WARNINGS CAN RESULT IN SERIOUS INJURY.'

ONE DAY I WILL WRITE ANOTHER BOOK, AND
WHEN I'M DONE I WILL CLIMB IT,
LIKE A STOOL OR A STEPLADDER,

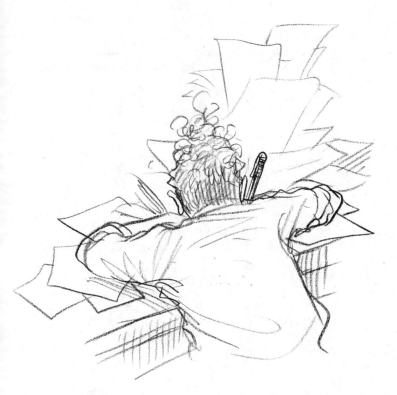

OR A HIGH OLD WOODEN LADDER PROPPED
AGAINST THE SIDE OF A PLUM TREE,
IN THE AUTUMN,

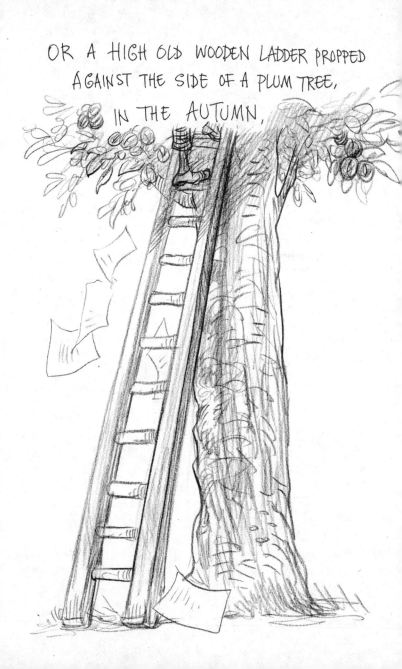

BUT FOR NOW I SHALL FOLLOW THESE WARNINGS,
AND FINISH MAKING THE
CHAIR.

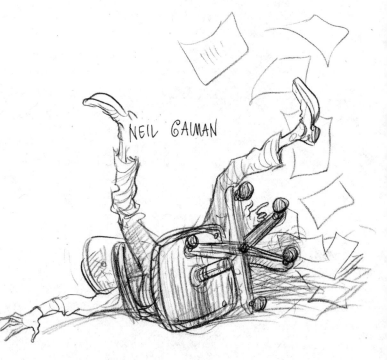

NEIL GAIMAN

MAKE GOOD ART

I ESCAPED FROM SCHOOL
AS SOON AS I COULD, WHEN
THE PROSPECT OF
FOUR MORE YEARS OF
ENFORCED LEARNING BEFORE
I'D BECOME THE WRITER I WANTED TO BE
WAS
STIFLING.

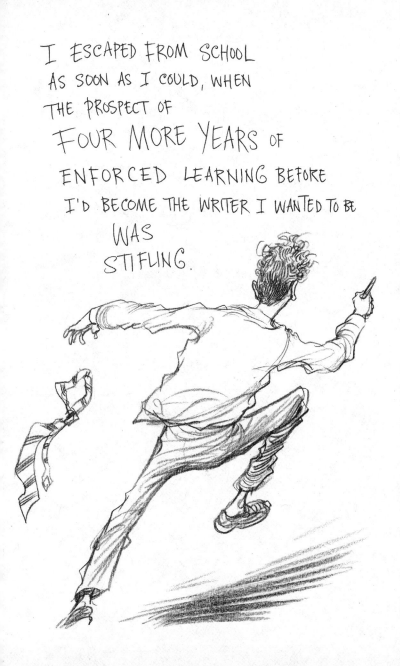

I GOT OUT INTO THE WORLD.
I WROTE, AND I BECAME
A BETTER WRITER THE MORE I WROTE,

AND I WROTE SOME MORE, AND
NOBODY EVER SEEMED TO MIND THAT
I WAS MAKING IT UP AS I WENT ALONG,
THEY JUST READ WHAT I WROTE
AND THEY PAID FOR IT,
OR THEY DIDN'T,
AND OFTEN THEY COMMISSIONED
ME TO WRITE SOMETHING ELSE FOR THEM.

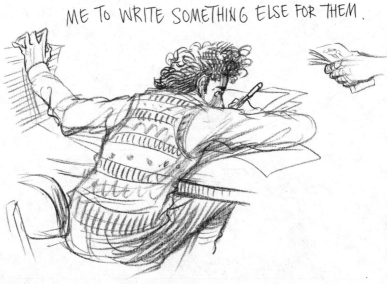

WHICH HAS LEFT ME WITH A HEALTHY RESPECT
AND FONDNESS FOR HIGHER EDUCATION
THAT THOSE OF MY FRIENDS AND FAMILY,
 WHO ATTENDED UNIVERSITIES,

 WERE CURED OF LONG AGO.

LOOKING BACK, I'VE HAD A REMARKABLE RIDE.

 I'M NOT SURE I CAN CALL IT A CAREER, BECAUSE
 A CAREER IMPLIES THAT I HAD SOME KIND OF
 CAREER PLAN, AND I NEVER DID.

THE NEAREST THING I HAD WAS A LIST I MADE
WHEN I WAS 15 OF EVERYTHING I WANTED TO DO:

TO WRITE AN ADULT NOVEL,
 A CHILDREN'S BOOK,
 A COMIC,
 A MOVIE,
 RECORD AN AUDIOBOOK,
 WRITE AN EPISODE OF
 DOCTOR WHO

... AND SO ON.

I DIDN'T HAVE A CAREER. I JUST DID THE
NEXT THING ON THE LIST.

SO I THOUGHT I'D TELL YOU EVERYTHING
I WISH I'D KNOWN STARTING OUT,
AND A FEW THINGS THAT, LOOKING BACK ON IT,
I SUPPOSE THAT I DID KNOW.

AND THAT I WOULD ALSO GIVE YOU
THE BEST PIECE OF ADVICE I'D EVER GOT,
WHICH I COMPLETELY FAILED TO
FOLLOW.

FIRST OF ALL:

WHEN YOU START OUT ON A CAREER IN THE ARTS YOU HAVE NO IDEA WHAT YOU ARE DOING.

THIS IS GREAT.

PEOPLE WHO KNOW WHAT THEY ARE DOING KNOW THE RULES, AND KNOW WHAT IS POSSIBLE AND IMPOSSIBLE.

YOU DO NOT.
AND YOU SHOULD NOT.

THE RULES ON WHAT IS POSSIBLE AND IMPOSSIBLE IN THE ARTS WERE MADE BY PEOPLE WHO HAD NOT TESTED THE BOUNDS OF THE POSSIBLE BY GOING BEYOND THEM.

AND YOU CAN.

IF YOU DON'T KNOW IT'S IMPOSSIBLE
 IT'S EASIER TO DO.

AND BECAUSE NOBODY'S DONE IT BEFORE,
THEY HAVEN'T MADE UP RULES TO STOP
ANYONE DOING THAT AGAIN,
 YET.

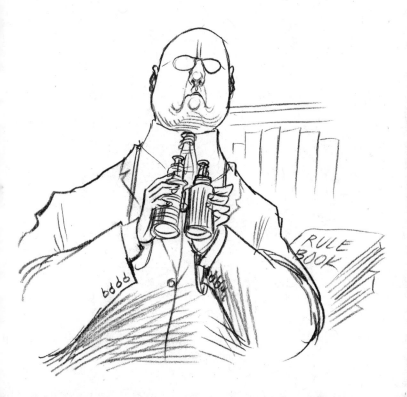

SECONDLY:

IF YOU HAVE AN IDEA OF WHAT YOU WANT
TO MAKE, WHAT YOU WERE PUT HERE TO DO,

THEN JUST GO AND DO THAT.

AND THAT'S MUCH HARDER THAN IT SOUNDS AND,

SOMETIMES IN THE END,

SO MUCH EASIER THAN YOU MIGHT IMAGINE.

BECAUSE NORMALLY, THERE ARE THINGS YOU HAVE TO DO
BEFORE YOU CAN GET TO THE PLACE YOU WANT TO BE.
I WANTED TO WRITE COMICS AND NOVELS AND
STORIES AND FILMS SO I BECAME A JOURNALIST
BECAUSE JOURNALISTS ARE ALLOWED TO ASK
QUESTIONS, AND TO SIMPLY GO AND FIND OUT HOW
THE WORLD WORKS, AND BESIDES, TO DO THOSE
THINGS I NEEDED TO WRITE AND TO WRITE WELL,
AND I WAS BEING PAID TO LEARN HOW TO WRITE
ECONOMICALLY, CRISPLY, SOMETIMES UNDER ADVERSE
CONDITIONS, AND ON TIME.

SOMETIMES THE WAY TO DO WHAT YOU HOPE
TO DO WILL BE CLEAR CUT, AND SOMETIMES
IT WILL BE ALMOST IMPOSSIBLE TO DECIDE
WHETHER OR NOT YOU ARE DOING THE CORRECT
THING, BECAUSE YOU'LL HAVE TO BALANCE
YOUR GOALS AND HOPES WITH
FEEDING YOURSELF, PAYING DEBTS, FINDING WORK,
SETTLING FOR WHAT YOU CAN GET.

SOMETHING THAT WORKED FOR ME WAS
IMAGINING THAT WHERE I WANTED TO BE
(AN AUTHOR, PRIMARILY OF FICTION, MAKING GOOD BOOKS,
MAKING GOOD COMICS, AND SUPPORTING MYSELF
THROUGH MY WORDS)

WAS A MOUNTAIN.

A DISTANT MOUNTAIN.

MY GOAL.

AND I KNEW THAT AS LONG AS I KEPT WALKING
TOWARDS THE MOUNTAIN I WOULD BE ALL RIGHT.

AND WHEN I TRULY WAS NOT SURE WHAT TO DO,
I COULD STOP, AND THINK ABOUT WHETHER
IT WAS TAKING ME TOWARDS OR AWAY FROM
THE MOUNTAIN.

I SAID NO TO EDITORIAL JOBS ON MAGAZINES, PROPER JOBS
THAT WOULD HAVE PAID PROPER MONEY, BECAUSE I KNEW
THAT, ATTRACTIVE THOUGH THEY WERE, FOR ME THEY
WOULD HAVE BEEN WALKING AWAY FROM
THE MOUNTAIN.

AND IF THOSE JOB OFFERS HAD COME ALONG EARLIER I
MIGHT HAVE TAKEN THEM, BECAUSE THEY STILL WOULD
HAVE BEEN CLOSER TO THE MOUNTAIN
THAN I WAS AT THE TIME.

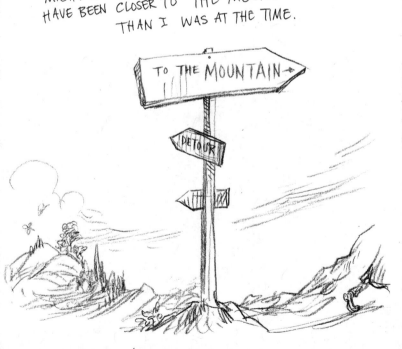

I LEARNED TO WRITE BY WRITING.

I TENDED TO DO ANYTHING AS LONG AS IT FELT LIKE AN ADVENTURE, AND TO STOP WHEN IT FELT LIKE WORK.

WHICH MEANT LIFE DID NOT FEEL LIKE WORK.

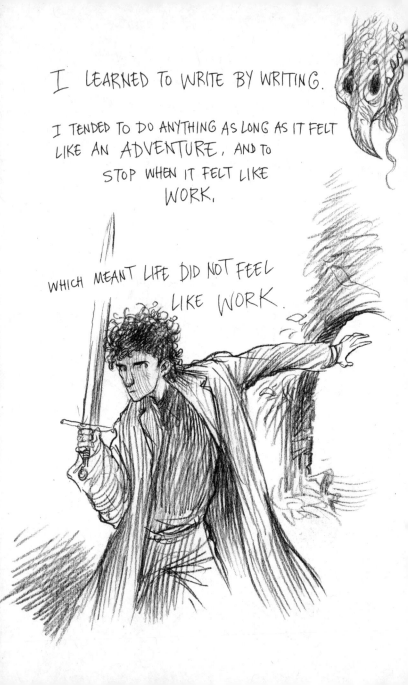

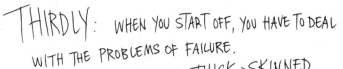

THIRDLY: WHEN YOU START OFF, YOU HAVE TO DEAL WITH THE PROBLEMS OF FAILURE.

YOU NEED TO BE THICK-SKINNED, TO LEARN THAT NOT EVERY PROJECT WILL SURVIVE.

A FREELANCE LIFE, A LIFE IN THE ARTS, IS SOMETIMES LIKE PUTTING MESSAGES IN BOTTLES, ON A DESERT ISLAND, AND HOPING THAT SOMEONE WILL FIND ONE OF YOUR BOTTLES AND OPEN IT AND READ IT, AND PUT SOMETHING IN A BOTTLE THAT WILL WASH ITS WAY BACK TO YOU:

APPRECIATION, OR A COMMISSION, OR MONEY, OR LOVE.
AND YOU HAVE TO ACCEPT THAT YOU MAY PUT OUT A HUNDRED THINGS FOR EVERY BOTTLE THAT WINDS UP COMING BACK.

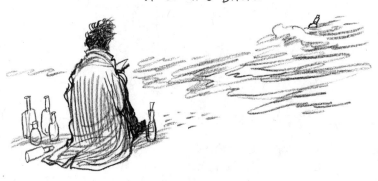

THE PROBLEMS OF FAILURE ARE PROBLEMS OF DISCOURAGEMENT, OF HOPELESSNESS, OF HUNGER. YOU WANT EVERYTHING TO HAPPEN AND YOU WANT IT NOW, AND THINGS GO WRONG.

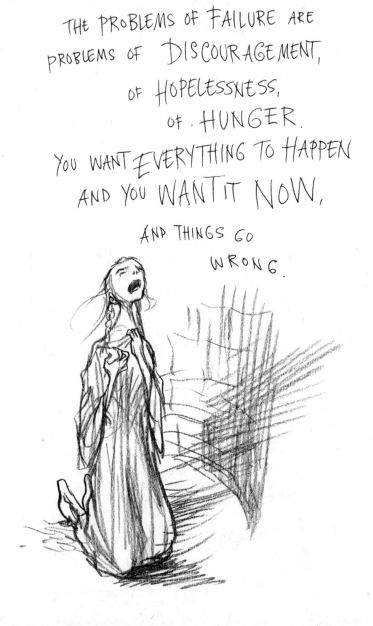

MY FIRST BOOK — A PIECE OF JOURNALISM I HAD DONE FOR
THE MONEY, AND WHICH HAD ALREADY BOUGHT ME AN
ELECTRIC TYPEWRITER FROM THE ADVANCE — SHOULD
HAVE BEEN A BESTSELLER. IT SHOULD HAVE
PAID ME A LOT OF MONEY. IF THE PUBLISHER HADN'T
GONE INTO INVOLUNTARY LIQUIDATION BETWEEN THE
FIRST PRINT RUN SELLING OUT AND THE SECOND PRINTING,
AND BEFORE ANY ROYALTIES COULD BE PAID, IT
WOULD HAVE DONE.

AND I SHRUGGED,

AND I STILL HAD MY ELECTRIC TYPEWRITER AND ENOUGH
MONEY TO PAY THE RENT FOR A COUPLE OF MONTHS, AND
I DECIDED THAT I WOULD DO MY BEST IN FUTURE
NOT TO WRITE BOOKS JUST FOR THE MONEY.
IF YOU DIDN'T GET THE MONEY, THEN YOU DIDN'T
HAVE ANYTHING. IF I DID WORK I WAS PROUD OF,
AND I DIDN'T GET THE MONEY,

AT LEAST I'D HAVE THE WORK.

EVERY NOW AND AGAIN, I FORGET THAT RULE, AND WHENEVER I DO, THE UNIVERSE KICKS ME HARD AND REMINDS ME.

I DON'T KNOW THAT IT'S AN ISSUE FOR ANYBODY BUT ME, BUT IT'S TRUE THAT NOTHING I DID WHERE THE ONLY REASON FOR DOING IT WAS THE MONEY WAS EVER WORTH IT, EXCEPT AS BITTER EXPERIENCE. USUALLY I DIDN'T WIND UP GETTING THE MONEY, EITHER.

THE THINGS I DID BECAUSE I WAS EXCITED,
AND WANTED TO SEE THEM EXIST IN REALITY,
HAVE NEVER LET ME DOWN, AND I'VE
NEVER REGRETTED THE TIME I SPENT
ON ANY OF
THEM.

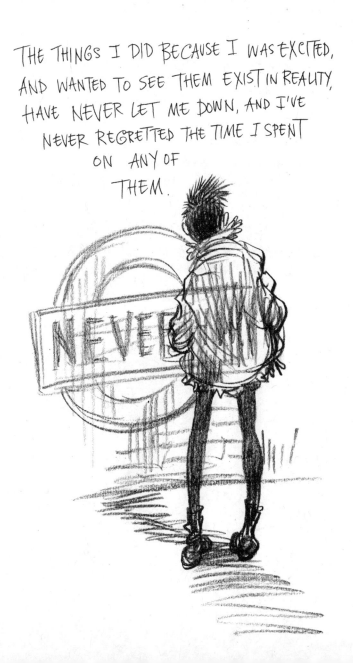

THE PROBLEMS OF FAILURE ARE HARD.
THE PROBLEMS OF SUCCESS CAN BE HARDER
BECAUSE NOBODY WARNS YOU ABOUT
THEM.

THE FIRST PROBLEM OF ANY KIND OF EVEN LIMITED SUCCESS
IS THE UNSHAKABLE CONVICTION THAT YOU ARE
GETTING AWAY WITH SOMETHING,
AND THAT ANY MOMENT NOW
THEY WILL DISCOVER YOU.
IT'S IMPOSTER SYNDROME, SOMETHING MY WIFE,
AMANDA, CHRISTENED THE FRAUD POLICE.

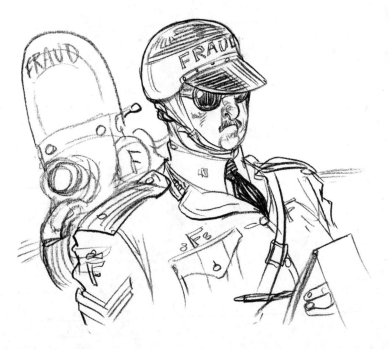

IN MY CASE, I WAS CONVINCED THAT THERE WOULD
BE A KNOCK ON THE DOOR, AND A MAN WITH A CLIPBOARD
(I DON'T KNOW WHY HE CARRIED A CLIPBOARD, IN MY HEAD, BUT HE DID)
WOULD BE THERE, TO TELL ME IT WAS ALL OVER,
AND THEY HAD CAUGHT UP WITH ME, AND NOW I WOULD
HAVE TO GO AND GET A REAL JOB, ONE THAT DIDN'T
CONSIST OF MAKING THINGS UP AND WRITING THEM
DOWN, AND READING BOOKS I WANTED TO READ.
 AND THEN I WOULD GO AWAY QUIETLY AND GET THE
KIND OF JOB WHERE YOU DON'T HAVE TO MAKE THINGS
UP ANYMORE.

THE PROBLEMS OF SUCCESS.
THEY'RE REAL, AND WITH LUCK YOU'LL EXPERIENCE
THEM. THE POINT WHERE YOU STOP SAYING YES
TO EVERYTHING, BECAUSE NOW THE BOTTLES YOU
THREW IN THE OCEAN ARE ALL COMING BACK,
AND HAVE TO LEARN TO SAY NO.

I WATCHED MY PEERS, AND MY FRIENDS, AND THE ONES WHO WERE OLDER THAN ME AND WATCHED HOW MISERABLE SOME OF THEM WERE: I'D LISTEN TO THEM TELLING ME THAT THEY COULDN'T ENVISAGE A WORLD WHERE THEY DID WHAT THEY HAD ALWAYS WANTED TO DO ANYMORE, BECAUSE NOW THEY HAD TO EARN A CERTAIN AMOUNT EVERY MONTH JUST TO KEEP WHERE THEY WERE. THEY COULDN'T GO AND DO THE THINGS THAT MATTERED, AND THAT THEY HAD REALLY WANTED TO DO; AND THAT SEEMED AS BIG A TRAGEDY AS ANY PROBLEM OF FAILURE.

AND AFTER THAT, THE BIGGEST PROBLEM OF SUCCESS IS THAT THE WORLD CONSPIRES TO STOP YOU DOING THE THING THAT YOU DO, BECAUSE YOU ARE SUCCESSFUL.

THERE WAS A DAY WHEN I LOOKED UP AND REALISED THAT I HAD BECOME SOMEONE WHO PROFESSIONALLY REPLIED TO EMAIL, AND WHO WROTE AS A HOBBY.
I STARTED ANSWERING FEWER EMAILS, AND WAS RELIEVED TO FIND I WAS WRITING MUCH MORE.

FOURTHLY: IF YOU'RE MAKING MISTAKES, IT MEANS
YOU'RE OUT THERE DOING SOMETHING.
AND THE MISTAKES IN THEMSELVES CAN BE USEFUL.
I ONCED MISSPELLED CAROLINE, IN A LETTER,
TRANSPOSING THE A AND THE O, AND I THOUGHT
'CORALINE LOOKS LIKE A REAL NAME...'

AND REMEMBER THAT WHATEVER DISCIPLINE YOU ARE IN,
WHETHER YOU ARE A
MUSICIAN OR A PHOTOGRAPHER, A FINE ARTIST OR A
CARTOONIST, A WRITER, A DANCER, A DESIGNER,
WHATEVER YOU DO,
YOU HAVE ONE THING THAT'S UNIQUE

YOU HAVE THE ABILITY TO
MAKE ART.

AND FOR ME, AND FOR SO MANY OF THE PEOPLE I HAVE
KNOWN, THAT'S BEEN A LIFESAVER.
THE ULTIMATE LIFESAVER.

IT GETS YOU THROUGH GOOD TIMES AND IT GETS YOU
THROUGH THE OTHER ONES.

LIFE IS SOMETIMES HARD.
THINGS GO WRONG, IN LIFE AND IN LOVE
AND IN BUSINESS AND IN FRIENDSHIP
AND IN HEALTH AND IN
ALL THE OTHER WAYS THAT
LIFE CAN GO WRONG.

AND WHEN THINGS GET TOUGH,
THIS IS WHAT YOU SHOULD DO...

MAKE

GOOD

ART.

I'M SERIOUS.

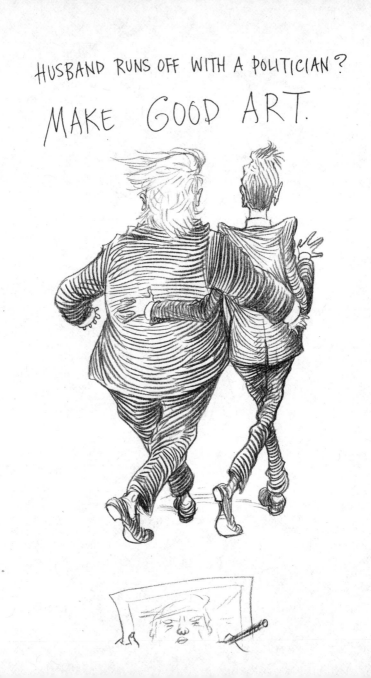

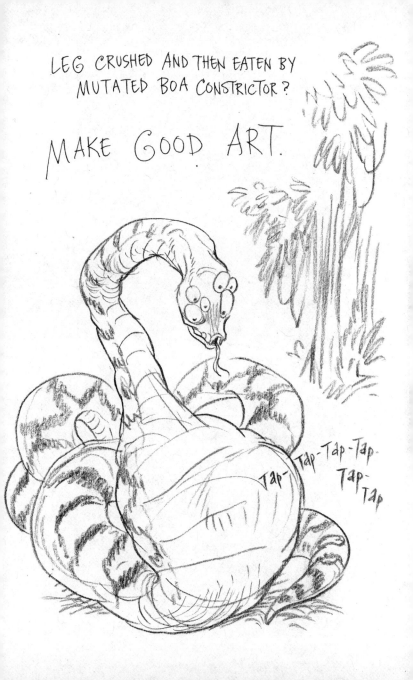

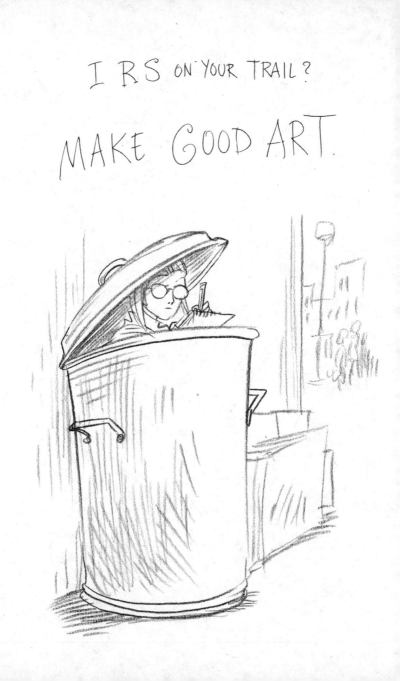

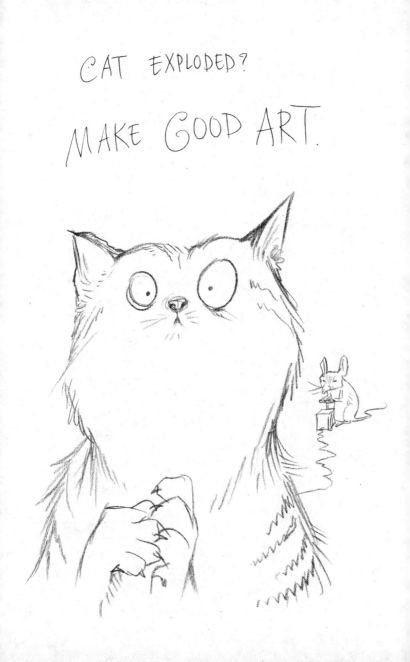

SOMEBODY ON THE INTERNET THINKS
WHAT YOU DO IS STUPID OR EVIL OR
IT'S ALL BEEN DONE BEFORE?

MAKE GOOD ART.

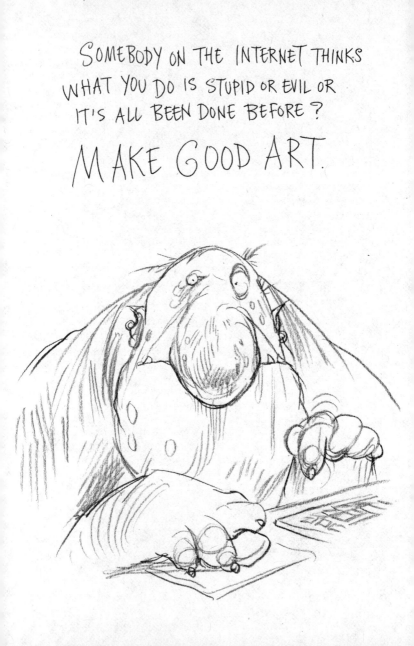

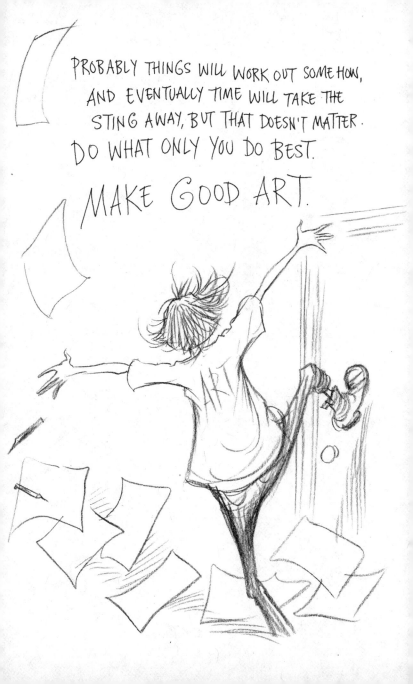

PROBABLY THINGS WILL WORK OUT SOMEHOW,
AND EVENTUALLY TIME WILL TAKE THE
STING AWAY, BUT THAT DOESN'T MATTER.
DO WHAT ONLY YOU DO BEST.

MAKE GOOD ART.

MAKE IT ON THE GOOD DAYS TOO.

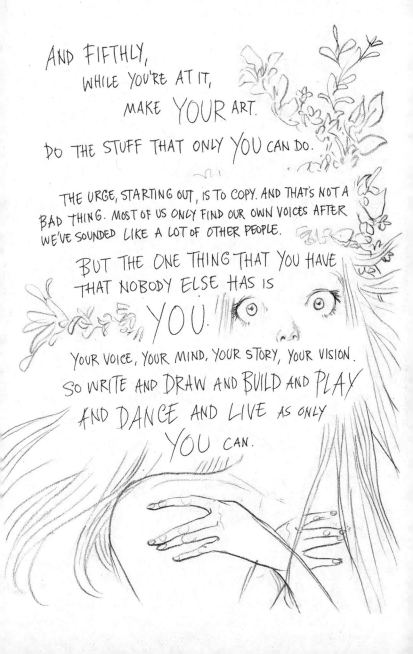

AND FIFTHLY,
WHILE YOU'RE AT IT,
MAKE YOUR ART.

DO THE STUFF THAT ONLY YOU CAN DO.

THE URGE, STARTING OUT, IS TO COPY. AND THAT'S NOT A
BAD THING. MOST OF US ONLY FIND OUR OWN VOICES AFTER
WE'VE SOUNDED LIKE A LOT OF OTHER PEOPLE.

BUT THE ONE THING THAT YOU HAVE
THAT NOBODY ELSE HAS IS
YOU.

YOUR VOICE, YOUR MIND, YOUR STORY, YOUR VISION.
SO WRITE AND DRAW AND BUILD AND PLAY
AND DANCE AND LIVE AS ONLY
YOU CAN.

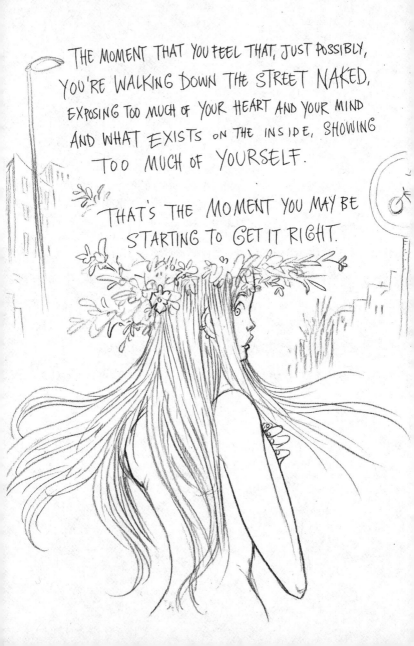

THE MOMENT THAT YOU FEEL THAT, JUST POSSIBLY, YOU'RE WALKING DOWN THE STREET NAKED, EXPOSING TOO MUCH OF YOUR HEART AND YOUR MIND AND WHAT EXISTS ON THE INSIDE, SHOWING TOO MUCH OF YOURSELF.

THAT'S THE MOMENT YOU MAY BE STARTING TO GET IT RIGHT.

THE THINGS I'VE DONE THAT WORKED THE BEST WERE THE
THINGS I WAS THE *LEAST* CERTAIN ABOUT, THE STORIES
WHERE I WAS SURE THEY WOULD EITHER WORK, OR MORE
LIKELY BE THE KINDS OF EMBARRASSING FAILURES
PEOPLE WOULD GATHER TOGETHER AND TALK ABOUT
UNTIL THE END OF TIME.

THEY ALWAYS HAD THAT IN COMMON:
LOOKING BACK AT THEM, PEOPLE EXPLAIN WHY THEY WERE
INEVITABLE SUCCESSES. WHILE I WAS DOING THEM,

I HAD NO IDEA.
I STILL DON'T.
AND WHERE WOULD BE THE FUN IN MAKING
SOMETHING YOU KNEW WAS
GOING TO WORK?

AND SOMETIMES THE THINGS I DID
REALLY DIDN'T WORK.

THERE ARE STORIES OF MINE THAT HAVE NEVER
BEEN REPRINTED. SOME OF THEM NEVER EVEN
LEFT THE HOUSE.

BUT I LEARNED AS MUCH FROM THEM
AS I DID FROM THE THINGS THAT
WORKED.

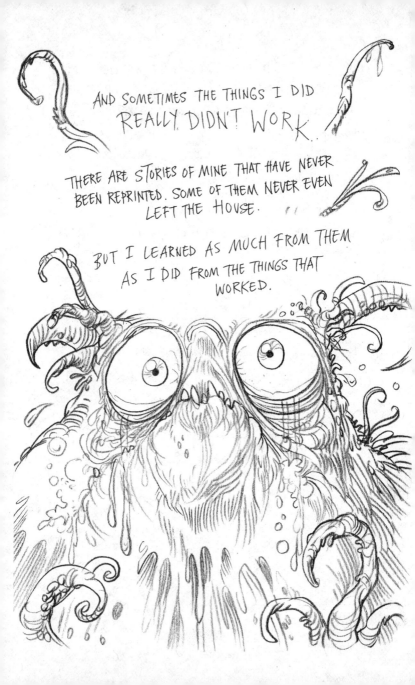

SIXTHLY:

I WILL PASS ON SOME SECRET FREELANCER KNOWLEDGE.

SECRET KNOWLEDGE IS ALWAYS GOOD.

AND IT IS USEFUL FOR ANYONE WHO EVER PLANS TO CREATE ART FOR OTHER PEOPLE, TO ENTER A FREELANCE WORLD OF ANY KIND. I LEARNED IT IN COMICS, BUT IT APPLIES TO OTHER FIELDS, AND IT'S THIS:

PEOPLE GET HIRED BECAUSE, SOMEHOW, THEY GET HIRED. IN MY CASE I DID SOMETHING WHICH THESE DAYS WOULD BE EASY TO CHECK, AND WOULD GET ME INTO TROUBLE, AND WHEN I STARTED OUT, IN THOSE PRE-INTERNET DAYS, SEEMED LIKE A SENSIBLE CAREER STRATEGY: WHEN I WAS ASKED BY EDITORS WHO I'D WORKED FOR, I LIED. I LISTED A HANDFUL OF MAGAZINES THAT SOUNDED LIKELY, AND I SOUNDED CONFIDENT, AND I GOT JOBS. I THEN MADE IT A POINT OF HONOUR TO HAVE WRITTEN FOR EACH OF THE MAGAZINES I'D LISTED TO GET THAT FIRST JOB, SO THAT I HADN'T ACTUALLY LIED,
I'D JUST BEEN CHRONOLOGICALLY CHALLENGED...

YOU GET WORK HOWEVER YOU GET WORK.

PEOPLE KEEP WORKING, IN A FREELANCE WORLD,
AND MORE AND MORE OF TODAY'S WORLD IS FREELANCE,
BECAUSE

1. THEIR WORK IS GOOD. ✓

AND 2. BECAUSE THEY ARE EASY TO
GET ALONG WITH, ✓

AND 3. BECAUSE THEY DELIVER THE
WORK ON TIME. ✓

AND YOU DON'T EVEN NEED ALL THREE. TWO OUT OF
THREE IS FINE.

PEOPLE WILL TOLERATE HOW UNPLEASANT YOU ARE ☒
 IF YOUR WORK IS GOOD ☑
 AND
 YOU DELIVER IT ON TIME. ☑

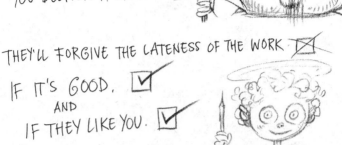

THEY'LL FORGIVE THE LATENESS OF THE WORK ☒

IF IT'S GOOD, ☑
 AND
 IF THEY LIKE YOU. ☑

AND YOU DON'T HAVE TO BE AS GOOD AS THE OTHERS ☒

IF YOU'RE ON TIME ☑
 AND
 IT'S ALWAYS A PLEASURE TO HEAR FROM YOU. ☑

I STARTED TRYING TO THINK WHAT THE BEST ADVICE
I'D BEEN GIVEN OVER THE YEARS WAS.

AND IT CAME FROM

STEPHEN KING

TWENTY YEARS AGO, AT THE HEIGHT OF THE SUCCESS OF

SANDMAN.

I WAS WRITING A COMIC THAT PEOPLE LOVED AND WERE TAKING
SERIOUSLY. KING LIKED SANDMAN AND MY NOVEL WITH TERRY
PRATCHETT, GOOD OMENS, AND HE SAW THE MADNESS, THE
LONG SIGNING LINES, ALL THAT, AND HIS ADVICE WAS THIS:

'THIS IS REALLY GREAT. YOU SHOULD ENJOY IT.'

AND I DIDN'T.

BEST ADVICE I GOT THAT I IGNORED. INSTEAD I
WORRIED ABOUT IT. I WORRIED ABOUT THE NEXT DEADLINE,
THE NEXT IDEA, THE NEXT STORY. THERE WASN'T A
MOMENT FOR THE NEXT FOURTEEN OR FIFTEEN YEARS THAT
I WASN'T WRITING SOMETHING IN MY HEAD, OR WONDERING
ABOUT IT. AND I DIDN'T STOP AND LOOK AROUND AND GO,

THIS IS REALLY FUN.

I WISH I'D ENJOYED IT MORE. IT'S BEEN AN AMAZING RIDE.
BUT THERE WERE PARTS OF THE RIDE I MISSED, BECAUSE
I WAS TOO WORRIED ABOUT THINGS
GOING WRONG, ABOUT WHAT CAME NEXT,
TO ENJOY THE BIT I WAS ON.

THAT WAS THE HARDEST LESSON FOR ME,
I THINK:

TO LET GO AND ENJOY
THE RIDE, BECAUSE THE
RIDE TAKES YOU TO SOME REMARKABLE
AND UNEXPECTED
PLACES.

I WISH YOU LUCK.
LUCK IS USEFUL.

OFTEN YOU WILL DISCOVER THAT THE HARDER YOU WORK,
AND THE MORE WISELY YOU WORK,
THE LUCKIER YOU GET.

BUT THERE IS LUCK, AND IT HELPS.

WE'RE IN A TRANSITIONAL WORLD RIGHT NOW, IF YOU'RE IN ANY KIND OF ARTISTIC FIELD, BECAUSE THE NATURE OF DISTRIBUTION IS CHANGING. THE MODELS BY WHICH CREATORS GOT THEIR WORK OUT INTO THE WORLD, AND GOT TO KEEP A ROOF OVER THEIR HEADS AND BUY SANDWICHES WHILE THEY DID THAT, ARE ALL CHANGING.

I'VE TALKED TO PEOPLE AT THE TOP OF THE FOOD CHAIN IN PUBLISHING, IN BOOKSELLING, IN ALL THOSE AREAS, AND NOBODY KNOWS WHAT THE LANDSCAPE WILL LOOK LIKE TWO YEARS FROM NOW, LET ALONE A DECADE AWAY.

THE DISTRIBUTION CHANNELS THAT PEOPLE HAD BUILT OVER THE LAST CENTURY OR SO ARE IN FLUX FOR PRINT, FOR VISUAL ARTISTS, FOR MUSICIANS, FOR CREATIVE PEOPLE OF ALL KINDS.

WHICH IS, ON ONE HAND, INTIMIDATING, AND ON THE OTHER, IMMENSELY LIBERATING.

THE RULES,
THE ASSUMPTIONS,
THE NOW WE'RE SUPPOSED TO'S

OF HOW YOU GET YOUR WORK SEEN, AND WHAT YOU DO THEN,

ARE BREAKING DOWN.

THE GATEKEEPERS ARE LEAVING THEIR GATES.
YOU CAN BE AS CREATIVE AS YOU NEED TO BE TO GET YOUR
WORK SEEN. YOUTUBE AND THE WEB (AND WHATEVER
COMES AFTER YOUTUBE AND THE WEB) CAN GIVE YOU
MORE PEOPLE WATCHING THAN TELEVISION EVER
DID.

THE OLD RULES ARE CRUMBLING
AND NOBODY KNOWS WHAT THE NEW RULES ARE.

SO MAKE UP YOUR OWN RULES.

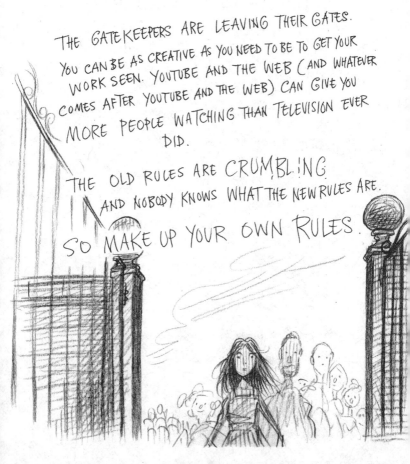

SOMEONE ASKED ME RECENTLY HOW TO DO SOMETHING SHE THOUGHT WAS GOING TO BE DIFFICULT. IN THIS CASE RECORDING AN AUDIOBOOK, AND I SUGGESTED SHE PRETEND THAT SHE WAS SOMEONE WHO COULD DO IT. NOT PRETEND TO DO IT, BUT PRETEND SHE WAS SOMEONE WHO COULD. SHE PUT UP A NOTICE TO THIS EFFECT ON THE STUDIO WALL, AND SHE SAID IT HELPED.

I ROCK AUDIO BOOKS

SO BE WISE.

BECAUSE THE WORLD NEEDS MORE WISDOM. AND IF YOU CANNOT BE WISE, PRETEND TO BE SOMEONE WHO IS WISE, AND THEN JUST BEHAVE LIKE THEY WOULD.

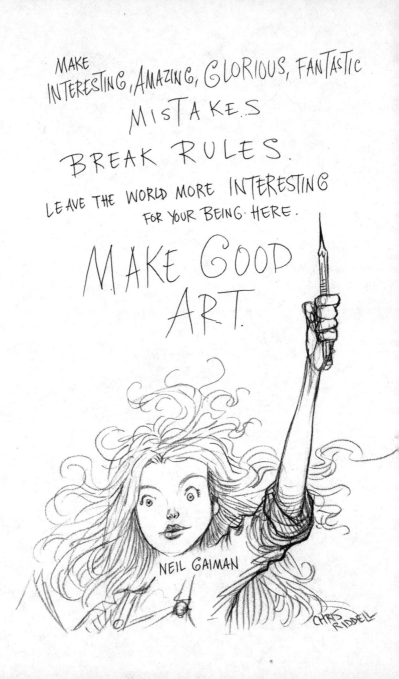

FINIS.

Neil Gaiman

Neil Gaiman is the bestselling author and creator of books, graphic novels, short stories, film and television for all ages, including *Neverwhere*, *Coraline*, *The Graveyard Book*, *The Ocean at the End of the Lane*, *The View from the Cheap Seats* and the critically acclaimed, Emmy-nominated television adaptation of *American Gods*.

The recipient of numerous literary honours, Neil has written scripts for *Doctor Who*, worked with authors and artists including Terry Pratchett, Chris Riddell and Dave McKean, and *Sandman* is established as one of the classic graphic novels. In 2017, he became a Goodwill Ambassador for UNHCR, the UN Refugee Agency. As George R. R. Martin says: 'There's no one quite like Neil Gaiman.'

🐦 @neilhimself

Chris Riddell

Chris Riddell is one of the UK's top contemporary illustrators. He has written and illustrated an exceptional range of books and is winner of many illustration awards, including the UNESCO Prize, the Greenaway Medal (three times) and the Hay Festival Medal for Illustration at the 2015 Hay Festival, where he was described as 'the greatest illustrator of his generation'. He served as the Waterstones Children's Laureate from 2015 to 2017.

Chris is also a renowned political cartoonist whose work appears in the *Observer*, the *Literary Review* and the *New Statesman*.

🐦 @chrisriddell50

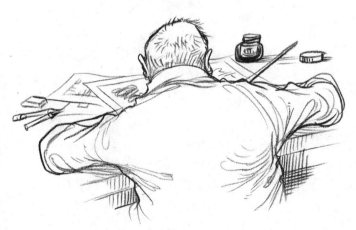

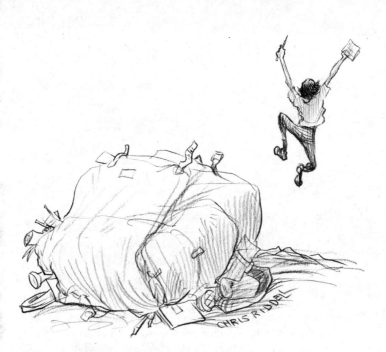

CREDITS

Published in Great Britain in 2018 by
Headline Publishing Group.

FIRST U.S. EDITION

Library of Congress Cataloging-in-Publication
Data has been applied for.

ISBN 978-0-06-290620-5

23 24 25 26 27 LBC 13 12 11 10 9